DEVON'S
MILITARY HERITAGE

Andrew Powell-Thomas

AMBERLEY

For Bryan & Sylvia, with love

First published 2020

Amberley Publishing
The Hill, Stroud
Gloucestershire, GL5 4EP

www.amberley-books.com

Copyright © Andrew Powell-Thomas, 2020

Logo source material courtesy of Gerry van Tonder

The right of Andrew Powell-Thomas to be identified
as the Author of this work has been asserted in
accordance with the Copyrights, Designs and Patents
Act 1988.

ISBN 978 1 4456 9491 7 (print)
ISBN 978 1 4456 9492 4 (ebook)

British Library Cataloguing in Publication Data.
A catalogue record for this book is available from the
British Library.

Typesetting by SJmagic DESIGN SERVICES, India.
Printed in Great Britain.

DEVON'S
MILITARY HERITAGE

Contents

Introduction

As the third largest county in Great Britain, Devon has rolling hills, national parks, vast swathes of farmland and some stunning coastline to its north and south. It also has a somewhat unexpected rich military heritage. So much so that it could be easy to live or commute in Devon, particularly if on holiday, and not see or appreciate the sheer range of history that lies all around, sometimes in plain sight.

Iron Age hill forts dating back to before 500 BC are scattered across the county thanks to the numerous natural hills that roll across the countryside. Now covered by mother nature, the vast earthworks are still visible if you look closely. Castles and fortified manor houses sprung up over the centuries as defensive centres of power for the rich and powerful and were used to keep the locals in check. The 1588 Spanish Armada was first engaged by the English fleet off Plymouth and the famous Devon mariners Sir Francis Drake and Sir Walter Raleigh, to name but two, had their homes here. Sites of skirmishes and battles fought between Royalist armies representing the king of England and local rebels during the English Civil Wars are now just empty fields with livestock grazing peacefully and in 1688, William of Orange landed in Brixham to launch the 'Glorious Revolution'. Devonport in Plymouth was developed as a major port and shipbuilding centre for the Royal Navy and over the years the Royal Marines, Devonshire Regiment and Royal Devon Yeomanry established military bases. The names of hundreds of young men who set off from the quiet life in Devon, never to return from the horrors of the First World War, are immortalised on the silent monuments that adorn nearly every town and village. Then of course, there's the Second World War, which saw armament factories, airfields, camps, defensive emplacements, as well as prisoner of war camps, built the length and breadth of Devon. The industrial centres faced German aerial bombardment and the county saw an influx of servicemen and women as the Allies prepared for D-Day, using Devon's beaches as an essential practice ground for the liberation of Europe.

Devon's proud military heritage continues to the present day, with military camps, training centres and docks still in use by Britain's armed forces.

This book aims to provide some background and insight into the range of localities right across the county, looking at their roles and what can be found there now. It is organised according to geographical location, using the ten established districts of Devon.

ENGLAND (UK)
DEVON COUNTY MAP

Legend
Coastline
County Capital
County Boundary

Somerset

Dorset

English Channel

East Devon

Mid Devon

Exeter

North Devon

Teignbridge

DEVON

ENGLAND (UK)

Torbay

Torridge

West Devon

South Hams

Plymouth

Bristol Channel

Cornwall

1. Torridge

Bideford

For a town with fewer than 20,000 residents, Bideford has a military history to rival most! Located on the estuary of the River Torridge, the manor of Bideford was recorded in the Domesday Book of 1086, and was held by the powerful Grenville family for many centuries. The town itself became an important port by the late 1500s and was used to supply many ships as well as import tobacco and other goods from the colonies. During the English Civil War, Bideford stood with the Parliamentarians against the Royalist forces of Charles I due in part to the king imposing a ship money tax. Around 1642, important Devon landowner James Chudleigh built a pair of earthwork artillery forts, each containing eight guns, to guard Bideford. These forts were placed on the high ground overlooking both sides of the River Torridge and prevented Royalist ships from using the river, and one of which was named Chudleigh Fort.

The Royalist armies saw many successes in the South West in 1643 and as a result, the Parliamentarians withdrew into the two small fortresses in Bideford and were besieged. Fierce fighting erupted, which eventually saw the Royalist forces storm the forts and the town of Bideford fall. Following the Civil War, the site lay empty, only being rebuilt in the

Bideford's Victoria Park is home to nine sixteenth-century Spanish cannons, and although they are identified as 'Armada cannons', local naval hero Grenville brought them back from a prior battle with the Spanish navy. (Author's collection)

A view of Chudleigh Fort, now a public park. (Author's collection)

nineteenth century by James Ley, who gave it fourteen gun emplacements instead of the eight the original fort had.

The site was later purchased by public subscription in 1921 for use as a public park in memory of those who died in the First World War. At the outbreak of the Second World War, Bideford prepared itself for around 3,000 evacuees from the bomb-hit big cities and a large number of these came and stayed for the duration of the conflict. Then in 1942 American GIs arrived in and around Bideford. Initially they were there to work in the radar stations across North Devon and Exmoor and on experimental things like the Great Panjandrum at Westward Ho! In 1943 scores more Americans arrived as training for D-Day began at beaches right across North Devon. Bideford Ordnance Experimental Station Depot O-617 was established to experiment on waterproofing equipment for the D-Day landings with a camp at Bowden Green and a Vehicle Repair Shop at Kingsley Road. As with most centres of population, Bideford had an Auxiliary Unit Patrol at Cleave Mine, where the men would have been expected to act as resistance if Britain was invaded. There was also POW camp number 694 at Handy Cross.

Holsworthy and Handy Cross POW Camps

At first glance Devon seems a peculiar place to have prisoner of war (POW) camps, but towns like Holsworthy, Crediton, Tiverton and Okehampton were judged to be secure enough to accommodate well-behaved prisoners, who had given their word of honour or 'parole' (from the French 'promise') to observe restrictions in return for limited freedom. These towns had a good muster roll and the surrounding terrain of moors and rural isolation would hinder any possible escape attempts.

Prisoner of War Working Camp 42 was built in the summer of 1942 on the site of the original Exhibition Field, adjoining Foresters Road and Dobles Terrace in the town of Holsworthy. From 1942 until 1948 it played host to many hundreds of Italian and later German prisoners of war, who worked on local farms throughout the area. The camp was opened in October 1942 when more than 750 Italian prisoners arrived, and the first German prisoners arrived in November 1944 followed by a constant stream of others arriving in the camp over the next four years, many of whom were taken prisoner after the liberation of the Channel Islands in May 1945.

After the last prisoner had left, plans were made to convert the camp into a displaced persons' camp for Poles. However, the scheme was dropped with many of the huts in the guards' compound and the prisoners' compound being converted to temporary housing.

Northam Burrows

Located in the Northam Burrows Country Park, north of Bideford and east of Westward Ho!, a Second World War 'Chain Home' radar station was built in 1941 and was one of a number constructed across Devon. With two pairs of transmitting/receiving masts (standing 235 feet in height) and a host of associated buildings, including substations,

A view of one of the radar masts at Northam Radar Station. (Courtesy of Richard Sumner, Westward Ho! History)

All that remains are the concrete stumps for the masts. (Courtesy of Westward Ho! History)

receiver towers, decoy targets and a domestic complex, the site covered around 24 hectares and was used to detect aircraft at long ranges, providing a vital defence to this part of the country. As the war came towards a close, the radar station was no longer required and ceased operating in 1944. In the years that followed, the masts and some buildings were dismantled, although the concrete stumps used for the transmitting masts and some structures do remain.

Sir Richard Grenville

The Grenville family became lords of the manor of Bideford in 1126 and played a major role in the town's development for many centuries to come. From this family came Sir Richard Grenville, who was born in the manor house in the town on 15 June 1542 and who played a major role in the transformation of the small fishing port of Bideford into what became a significant trading port with the new American colonies. He was a man of many talents; as well as being lord of the manor, he was also a soldier, an armed merchant fleet owner, privateer, colonizer and explorer. He first developed his naval skills through the 1566 Hungarian campaign and activity in Ireland in 1569, before he took part in the early attempts to settle the New World and later specialised in tobacco importation, through which his hometown became an important port.

In 1585, Grenville was admiral of a seven-strong fleet that took English settlers to establish a military colony on Roanoke Island, off the coast of modern North Carolina, USA. As his stock rose, in 1587 Grenville was appointed Deputy Lieutenant of the West Country by the Privy Council, where it was his job to organise the defences of Devon and Cornwall in preparation for the expected attack by the Spanish Armada

the following year. In 1588 the Spanish did attack, and Grenville led five of his ships to Plymouth to defend England in a decisive battle. With his increased reputation, Grenville was appointed Vice-Admiral of the Fleet under Thomas Howard with the aim of maintaining a squadron at the Azores, in order to delay and hinder the return to Spain of the Spanish South American treasure fleets. As captain of *Revenge*, a state-of-the-art galleon, he met fifty-three Spanish warships near Flores in the Azores in 1591 but refused to surrender. In a three-day running battle, in which they were boarded no less than three times, the *Revenge* caused great damage to many of the Spanish ships, before Grenville was fatally wounded.

Westward Ho!

The beach at Westward Ho! was, like many in the West Country, used for various training exercises by the military in the Second World War, but it was also instrumental in the development of one of the more unusual weapon ideas of the time. When the British military turned its thoughts from the defence of the country to a potential attack on northern France, inventors and engineers came up with many ideas for secret and special weapons and The Great Panjandrum was one of these. It was essentially a giant Catherine

The Great Panjandrum – one of Britain's experimental weapons.

wheel with two steel wheels, each 10 feet in diameter and joined by a drum-like axle that contained high explosives. The gradient of the beach and its tidal conditions meant the Westward Ho! was the perfect place to see whether the idea of a self-propelling weapon that could move at 60 miles an hour before hitting a target was possible. Construction began in August 1943 and a number of trials were held over the next few months, but there were constant issues with achieving the speed required, and crucially, maintaining control of its direction, and the project was eventually scrapped.

RAF Winkleigh

Just five minutes' flying time to the North Atlantic and less than an hour from France, spring 1940 saw building work commence for the purpose-built RAF Winkleigh, on flat moorland near the village of Winkleigh. 1 January 1941 saw the first RAF plane land and for the next ten years, the airfield was used by various British, American, Polish and Canadian squadrons. Of particular note is the use of the airfield during the Second World War by the RAF's special operations 161 Squadron. Known as 'Black' squadron for their jet black-coloured aircraft, they would leave the airfield in the dead of night with an additional fuel tank under the fuselage, possibly heading off into the very heart of Europe, delivering and collecting spies on perilous and covert missions.

Like so many other airfields, after the war RAF Winkleigh ceased to be operational, and the site is now used by the West of England Transport Collection.

Canadian aircrew in front of a Mosquito at RAF Winkleigh in 1944. (Courtesy of Jackie Freeman)

Today the footprint of Winkleigh Airfield remains, but it is now used as a storage facility and industrial estate. (Courtesy of Richard E. Flagg)

2. North Devon

Affeton Castle. (Courtesy of Robert Cutts CC BY-SA 2.0)

Affeton Castle

In 1434, Hugh Stucley built a fortified manor house on the Affeton estate within the valley of the Little Dart River near the village of East Worlington. During the English Civil War of the 1640s the house was destroyed and all that remained was the ruins of the medieval gatehouse. Restored in 1868, these remnants of the castle were converted into the private residence of the Stucley baronets in 1956.

Assault Training Centre

When the tide of the Second World War changed and thoughts turned to the amphibious assault on mainland Europe, the necessity of training the troops in terrain similar to that of Normandy meant that the long sweeping beach at Woolacombe was used extensively in the years preceding D-Day, due to its similarities to Omaha Beach in Normandy. In fact, from 1 September 1943, this whole stretch of coastline became an Assault Training Centre (ATC) for the US Army, with its headquarters based at the Woolacombe Bay Hotel.

Other buildings were requisitioned as billets and camps were erected to house the soldiers, whilst demolition training areas, makeshift fortifications and pillboxes were

built to facilitate training. Infantrymen would participate in an intense three-week course, acclimatising themselves to sea voyages in small landing craft launched by the US Navy, who were based at Instow and Crow Point. They were introduced to new weapons and tactics using live ammunition under combat conditions on the Braunton Burrows,

It is easy to see why the long, sweeping beaches of North Devon were used to practise for landing in Normandy. (Courtesy of Miranda Wood CC BY-ND 2.0)

Thousands of US troops trained for D-Day on the beaches of North Devon. (Courtesy of US Army)

culminating in a full-scale beach assault with smoke, tanks and artillery at Woolacombe beach. Some of the structures built at this time do remain, including a pillbox in the harbour wall at Instow, but the most notable are six concrete dummy tank landing craft used to perfect the loading and unloading of vehicles on Braunton Burrows.

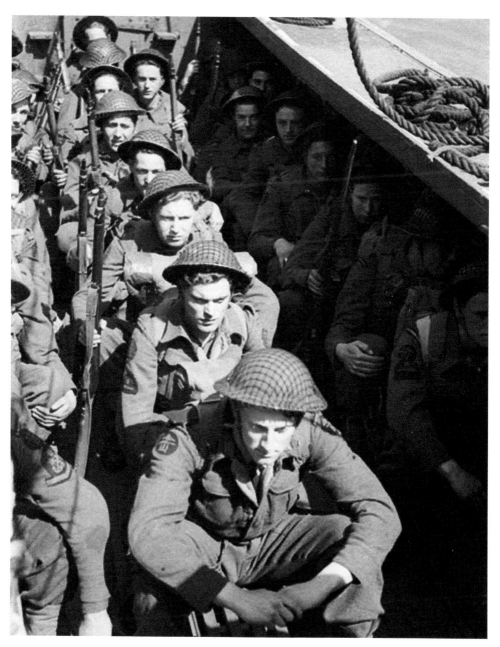

Conditions were cramped on board the landing craft. (Courtesy of Lt Richard G. Arless – Canada Dept. of National Defence/Library and Archives Canada)

One of the concrete
landing craft at
Braunton Burrows.
(Courtesy of Roger
Cornfoot CC BY-SA 2.0)

Barnstaple

Following the Norman invasion of 1066, the Bishop of Coutances, Geoffrey de Mowbray, built a wooden castle in the centre of the town due to its prominent river crossings. As the town was fortified, the castle was soon redeveloped in stone, but less than 200 years

The motte is all that remains of Barnstaple Castle. (Author's collection)

after it was originally built, the need for a defensive position in Barnstaple declined and the castle's fortunes waned. By 1326 the castle was nothing more than a ruin and the great stones once used for its walls were reused in other buildings around the town, leaving just the tree-covered motte today.

During the English Civil War, Barnstaple was besieged by Royalist troops on 12 September 1644 and held out for just under a week before being taken on 17 September.

RAF Chivenor

Built in October 1940 on the site of a civilian airfield, RAF Chivenor opened as a training base for pilots operating Bristol Beaufighters, Bristol Blenheims and Bristol Beauforts. However, from 1942 onwards, anti-submarine patrolling took centre stage as the build-up to the liberation of Europe commenced. By 1943 there were four squadrons of Wellingtons at the base manned by servicemen from the UK, Canada and Poland.

After the war, sorties collecting weather information were flown and by the 1950s the airfield was mainly used for operational training and civilian flights, until the RAF base closed in 1995. However, the Royal Marines took control of the base, becoming known as Royal Marines Base Chivenor (RMB Chivenor), and it remains an operational base for them, providing flights for the Air Training Corps and Combined Cadet Force.

The opening ceremony for the civil airfield at Chivenor in 1934. (Courtesy of Maurice J. Wickstead)

ARP Post F at Ilfracombe Hospital during the Second World War. (Courtesy of Craig Smith)

Ilfracombe

The natural harbour at Ilfracombe has seen this area inhabited since the Iron Age, with the remains of a hill fort being found at the top of the Hillsborough nature reserve. The ditches and earthworks are over 250 metres in length, making it one of the largest enclosures in the county.

At the outbreak of the English Civil War, like many other ports at the time, Ilfracombe was in support of the Parliamentarians and was stormed multiple times by the Royalists, first on 20 August 1644, where houses were burned and eleven locals killed, and again in April 1646.

The First World War saw the Territorial Volunteers leave for France on 20 August 1914, with a staggering 157 losing their lives in the conflict. The Second World War saw the American Pay Corps garrisoned in the town as the larger beaches across North Devon were used as training areas for D-Day. Hele Beach and the slipway were covered in barbed wire and around the coast at Widmouth the remains of a coastal battery can still be found.

Putsborough Bay

A small footnote in the overall heritage of Devon, but during the Second World War Putsborough Bay (officially known as Morte Bay) was used as a high-altitude bombing range practice ground. A large concrete arrow indicator helped identify the target on the beach below and an observation post 30 metres or so to the west of it still remains today.

A view of the bombing range directional arrow and observation tower at Putsborough Bay. (Courtesy of Richard E. Flagg)

Royal Devon Yeomanry

After the First World War it was decided that only the most senior yeomanry regiments would be retained as horsed cavalry and in 1920, the Royal Devon Yeomanry was formed from amalgamating the Royal 1st Devon Yeomanry and the Royal North Devon Yeomanry. Originally organised into two twelve-gun batteries, the field regiments were reorganised into three eight-gun batteries after the regiments experiences with the British Expeditionary Force (BEF) in 1940. The 96th Field Regiment served primarily with the Home Forces for most of the war before transferring to India in 1945. The 142nd Field Regiment went to Italy in 1943 and played a part in the Allied landings at Sicily, Anzio and the Battle of Monte Cassino.

After the war the regiments were reformed and amalgamated a number of times. The Royal Devon Yeomanry now serves as D Squadron, Royal Wessex Yeomanry and are based in Barnstaple and Paignton. The Royal Devon Yeomanry Museum is contained within the Museum of Barnstaple and North Devon and is a fascinating place to find out more about this historic fighting unit.

Like most towns, Barnstaple has a war memorial commemorating the names of those lost in conflict. (Author's collection)

Museum of Barnstaple and North Devon. (Author's collection)

Watermouth Bay

The rather unassuming but beautiful Watermouth Bay, located a mile to the east of Ilfracombe, provides an important footnote in arguably the most significant moment of the Second World War. The long-term success of D-Day and the liberation of Europe relied on the Allies being able to supply its forces with everything it needed, including enough fuel and oil to keep the tanks and trucks moving. The solution was PLUTO (Pipeline Under the Ocean), a new type of pipeline that would be laid across the English Channel after the Allies had landed in Normandy and would enable fuel to be pumped across for use by the thousands of vehicles. Like any new idea, tests would be needed beforehand, and in 1942 a long-term trial of PLUTO took place. A prototype pipeline was laid out by HMS *Holdfast* (a converted cable-laying ship) stretching 27 miles from the Swansea oil refinery to Watermouth Bay. The 2-inch-wide cable allowed 125 tons of oil a day for three weeks to be pumped, and with this rehearsal a success, plans were put in place for the real thing. Despite this planning, PLUTO didn't start supplying petrol and oil to the Allied forces on mainland Europe until September 1944, three months late, and by VE Day, it had only been responsible for around 8 per cent of the fuel actually delivered to troops.

3. West Devon

Sir Francis Drake

One of England's most celebrated and revered sailors, Francis Drake was born in Tavistock around 1540. The eldest of twelve sons, he became the purser of a ship at the age of eighteen and so began a life on the sea. Although most well-known for his part in defeating the Spanish Armada, he had numerous exploits prior to that, which had already ensured his status. In 1568, Drake went on his third voyage with his second cousin Sir John Hawkins, attacking Portuguese towns and ships on the coast of West Africa before heading across to the Americas to sell their cargoes, which included slaves. The fleet of seven ships belonging to the English privateers was attacked by Spanish warships, resulting in all but two of the ships surviving and Drake himself only just escaping. A year later, in 1569, he married Mary Newman at St Budeaux Church in Plymouth before embarking on his first independent enterprise in 1572, attacking the Panamanian town of Nombre de Dios, where Spanish galleons would pick up the gold and silver they were looting from Peru.

Injured in July 1572, Drake stayed in the area for over a year raiding Spanish shipping, eventually returning home to Plymouth in August 1573 with his ships laden with gold and silver – he was seen as a hero in England but viewed as a pirate by the Spanish. In 1577, Queen Elizabeth I sent Drake on an expedition against the Spanish along the Pacific Coast of the Americas. In his ship, the *Golden Hind*, he captured Spanish ships full of treasure and spices and even sailed as far north as modern-day California, claiming it for the English.

Nearly three years after he set out, he returned to Plymouth on 26 September 1580, becoming the first Englishman to circumnavigate the globe and received a hero's welcome. Later that year, with his new-found wealth and fame, he purchased the large manor house of Buckland Abbey. A favourite of Queen Elizabeth I, she presented him with a jewel with her portrait and in 1581 knighted him aboard the *Golden Hind*.

In September 1585, under the orders of the Queen, Drake led an expedition of twenty-one ships to attack Spanish colonies, successfully plundering and raiding many settlements (including the city of Vigo) before returning to Portsmouth in July 1586 with his status and reputation enhanced even further. Seemingly unstoppable, in 1587 Drake 'singed the beard of the King of Spain' by attacking Cadiz and Corunna, two of Spain's major ports, destroying in excess of thirty-five naval and merchant ships. Promoted to Vice Admiral of the English fleet, Drake's most famous moment came in 1588, when the Spanish Armada was successfully defeated in its attempt to invade England.

Sir Francis Drake. (David Merrett, CC BY 2.0)

Gidleigh Castle

On the edge of Dartmoor, the small village of Gidleigh has the ruined remains of a fortified manor house that was built by William de Prouz in the fourteenth century. There are no records of any military action taking place here and all that is left now is a small two-storey keep and an undercroft.

RAF Harrowbeer

Sitting on the boundary of Dartmoor National Park, ideally placed between Plymouth and Tavistock, RAF Harrowbeer was constructed in 1940 at Yelverton and operated until 1950. The Air Ministry had decreed that all new airfields would be built with tarmac runways due to the difficulties faced on grass airfields, and rather incredibly, rubble from the Plymouth blitz was transported to Yelverton to form part of the hard core for the new runways. In an effort to lower the risk to pilots, all shops in the village were reduced to single-storey buildings, some were demolished altogether, and roads were diverted. A large house called Ravenscroft was used as station HQ (this is now a nursing home) and another building, Knightstone, became the control tower and this is now a restaurant and tearoom that is also home to exhibits about the airfield.

A Spitfire of 312 Squadron being rearmed. (Courtesy of Jerry Brewer)

In 1941 the airfield was operational with 500 squadron arriving with their Bristol Blenheims before 130 Squadron, 276 Squadron and the Polish Poznan Squadron all took up residence before the year was out. Due to its proximity to Plymouth, the airfield was expanded in 1942 and many more squadrons were stationed here over the years, defending the airspace as well as attacking enemy shipping. In 1944, Harrowbeer played its part in Operation Overlord as many Squadrons of Spitfires were stationed here to help defend against enemy air attacks.

The last active unit left in June 1945 and the end of the war saw the end of operational use for Harrowbeer as it was gradually closed and decommissioned. Although a road was constructed across the site in the 1960s, the billets used by the station's aircrews were actually used as temporary accommodation for local families, some right up until the 1970s. Today, aside from a few of the picket posts and the blast pens on the perimeter of the airfield, all that remains are the concrete footprints of the runways and hangars.

April 1943 at RAF Harrowbeer. An Avro Anson in the foreground, to the right a Spitfire and back left is a Walrus, with the airfield's Bellman Hangar on the left. (Courtesy of Stephen Fryer)

The footprint of the airfield can still be seen today. (Courtesy of D. Keeling)

A view of one of the blister pens today. (Courtesy of Richard E. Flagg)

The remains of the stone keep at Lydford. (Author's collection)

Lydford Castle

The small village of Lydford has the unlikely distinction of having two castle structures to talk about. The first, a small ringwork built in the years immediately after the Norman invasion of 1066, served to keep the local population in check, and aside from earthworks, nothing else remains of this defensive position.

Lydford's other castle was constructed in 1195 and was used primarily to administer the laws of the land as a court – and as a prison for those who broke them. It is possibly the earliest example of a purpose-built prison in England. Built on a mound of earth, the two-storey tower measures 16 metres in each direction.

Okehampton Castle

The motte-and-bailey castle at Okehampton traces its origins to the immediate aftermath of the Norman conquest of 1066. As sporadic violence flared up from discontent locals, a Norman Lord, Baldwin FitzGilbert, was given significant lands in the county in return for quashing a rebellion in 1068, and so began the building of the castle. The location was paramount. The long, thin rocky outcrop was perfect as it protected one of the significant routes from Devon to Cornwall as well as two nearby fords across the West Okement River. A new town was established near to the castle and this became known as Okehampton.

The castle was successful in providing a strong military base from which to keep the local population in check, and it was later requisitioned in 1194 by King Richard I to assist in the royal defence of Devon, with some additional works being carried out on the site. Towards the end of the thirteenth century the castle had fallen into a state of disrepair, before it was modified to become less of a military stronghold and more of a hunting lodge and retreat. In the fifteenth century, the Courtenay family became embroiled in

the 'War of the Roses', resulting in the castle being confiscated by King Edward IV. By the mid-sixteenth century the castle began to fall into decay, so much so that in 1643 during the English Civil War, despite the Battle of Sourton Down taking place nearby, neither side used the castle as it no longer served a military purpose. Today, its ruins stand as a reminder of the importance this castle once had.

The atmospheric ruins of Okehampton Castle. (Author's collection)

A view of the castle buildings from the keep, with the town of Okehampton in the background. (Author's collection)

IN MEMORY OF
OKEHAMPTON II
(FOLLY GATE)
AIRFIELD

OPENED 1928
CLOSED 1960

DEDICATED TO ALL UNITS
AND PERSONNEL BASED HERE

AIRFIELDS
OF BRITAIN
Conservation Trust

www.abct.org.uk

UNVEILED BY
KENNETH P. BANNERMAN
DIRECTOR GENERAL ABCT
12.04.2011

Little remains at the site today bar some empty fields, one site building and this memorial.
(Courtesy of Richard E. Flagg)

RAF Folly Gate (near Okehampton)

Originally opened in 1928 with minimal infrastructure, this small airfield was used by aircraft supporting artillery practice camps taking place on Dartmoor. In 1942 the airfield was improved to include an off-airfield storage site as it became a Forward Holding Unit. In 1944, the airfield was used by the 227 Field Artillery Battalion US Army in the months leading up to D-Day and ceased to be used as an operational military base after the end of the Second World War on 24 July 1945, before ultimately closing in 1960.

Prisoner of War Camps

With Dartmoor being so vast and inhospitable, it is unsurprising that a number of POW camps were located here. Bickham POW Camp, near Yelverton; Winsford Towers POW Camp, Beaworthy; and Bridestow POW Camp, Okehampton all had German and Italian soldiers who were often used for manual labour, especially on the farms. Those from Bickham POW Camp were also used to clear the rubble and debris from the streets of Plymouth during the blitz.

Rippon Tor Rifle Range

One of the more unexpected sights to come across if you're exploring Dartmoor is the now disused rifle range near the village of Widecombe-in-the-Moor. At the outbreak of

The huge stop butt at Rippon Tor Rifle Range. (Author's collection)

the Second World War much of Dartmoor was used for military training, and at Rippon Tor, a huge structure was built in 1941 as a rifle range. The largest section, a red-brick stop butt which received the shots being fired, measures 55 metres long, 15 metres wide and nearly 10 metres high. On the opposite side is the markers gallery and to the east there are four large mounds of earth that the soldiers would fire from. Nearby, there are other ancillary buildings still standing of this once expansive rifle range.

4. Mid Devon

Bampton Castle

A defensive mound was originally built in Saxon times and in the aftermath of the Norman conquest, the Normans built a motte-and-bailey wooden castle overlooking the River Batham in around 1067 to consolidate their newly found power in the region. The feudal barony of Bampton had its head here, but in 1136 there was a dispute with King Stephen about the ownership of lands around Uffculme, who besieged the castle, forcing it to surrender. Later, the new lord of the manor, Richard Cogan, obtained a royal licence to crenelate it and a stone mansion was built on the motte.

By the seventeenth century the mansion and walls were crumbling down, so much so that when the English Civil War reached the area in 1645, Royalists from Tiverton Castle burnt down the town of Bampton without the castle being given a second thought. All the stonework has been removed since then, leaving just the motte on the outskirts of the village.

Bampton. (Alison Day, CC BY-ND 2.0)

Bampton Road POW Camp and Cruwys Morchard POW Camp, Tiverton

The area around Tiverton had two prisoner of war camps. Bampton Road POW Camp, just off Bolham Road, saw low-threat German prisoners living in around fifty Nissen huts whilst spending the days working on the local farms. This site is now occupied by Tiverton High School and Petroc College. To the west of Tiverton, Cruwys Morchard POW camp housed Italian prisoners who, like their German counterparts, worked on the land.

Bickleigh Castle

Built in the eleventh century and mentioned in the Domesday Book, Bickleigh Castle was a Norman motte castle and was given by King William to Sir Richard de Redvers. In the fifteenth century the powerful Courtenay family built a stone mansion on the site and also incorporated some of the earlier buildings, such as the chapel, into their designs for the land.

During the English Civil War of the seventeenth century, Charles I's queen, Henrietta Maria, stayed in the castle as a guest of Sir Henry and Lady Dorothy Carew in 1644, on her way to Exeter. As a result of this, at the end of 1645, Fairfax's Parliamentarian troops attacked the castle for its strong Royalist links and a lot of the buildings and structures were slighted beyond repair and demolished. In the aftermath, the Carew family salvaged what they could, turning Bickleigh into the fortified manor house that you see today.

The fortified manor house at Bickleigh as it stands today. (Courtesy of Alison Day CC BY-ND 2.0)

Hemyock Castle

Located in the Culm Valley on the western side of the village of Hemyock, Sir William Asthorpe acquired royal permission to build a new castle on the site in 1380, giving him power, protection and prestige. With a large gatehouse, moat and a high curtain wall over 1-metre thick, the castle would have looked impressive with its seven circular towers dominating the surrounding area.

By the sixteenth century the castle was largely in ruins, save for a tower or two, but when the English Civil War broke out in 1642, a Royalist named Lord Poulett took the castle, only for it to be later claimed by the Parliamentarians and used as a prison. When Charles II was restored to the throne, parts of the castle were torn down and then it fell into different hands, resulting in Castle House being built inside the walls and leaving the private property that stands there today.

Tiverton Castle

It is no surprise that the town that straddles the rivers Exe and Lowman, a site of historic strategic importance, has the remains of a castle set in a defensive position overlooking the waterways. As the seat of the court of the 'Hundred of Tiverton', the castle was first built in 1106 by Richard de Redvers after he was granted the large and important manor of Tiverton by Henry I.

The gatehouse of Tiverton Castle. (Author's collection)

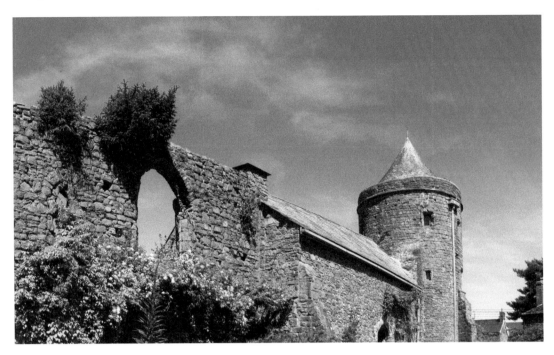

The remaining structures of the castle incorporate a 3-acre garden. (Author's collection)

The wooden motte-and-bailey castle on the bank of the River Exe was redesigned and remodelled in the thirteenth and fourteenth centuries, making it an imposing stone structure that became a Royalist stronghold during the English Civil War of the seventeenth century. Despite this, Parliamentarian troops laid siege to the castle, setting up their headquarters at Blundell's School, and stationed their artillery on Shrink Hills approximately half a mile from Tiverton Castle. It is said that whilst they were still finding their range, a lucky shot hit one of the chains holding up the castle's drawbridge, allowing them to gain entry, ending the siege almost before it had started! In taking the castle, the majority of the defensive structures of this once vast bastion were demolished to prevent any military reuse of the structure by the Royalists.

Today, the part-Grade I listed castle is privately owned, but is opened on certain days of the year.

5. East Devon

Axminster

Axminster, a town renowned for making carpet, also has a footnote of Second World War military history. Axminster was one of the defensive islands that formed the Taunton Stop Line – a defensive 'wall' that stretched for approximately 50 miles across Somerset, a small part of Dorset, and a few miles of Devon to hold up any potential German invasion in the summer of 1940. A number of pillboxes, roadblocks and anti-tank obstacles remain in and around the town. As the war continued, the US Army had a military base in the 'Milwey Rise' area of town, which included the 315th Station Hospital, which saw significant use in the immediate aftermath of the D-Day landings in 1944.

Part of a concrete roadblock at one end of a bridge over the River Axe. (Author's collection)

One of many pillboxes in the Axminster area overlooking the River Axe and covering the vast open fields. (Author's collection)

Axmouth

Like Axminster, the nearby town of Axmouth formed part of the Taunton Stop Line in the Second World War. At the mouth of the River Axe, and potentially facing a German invasion force from across the Channel first, the road bridge was mined for demolition and pillboxes lined the eastern side of the river, with a small coastal battery overlooking the sea itself.

The structural remains of the Coastal Artillery Beach Battery at Axmouth is now used as a picnic spot. (Author's collection)

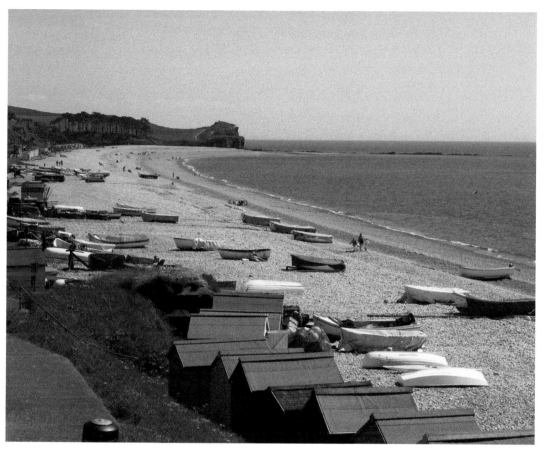

It is easy to see why the threat of an invasion was so great in seaside resorts like Budleigh Salterton. (Author's collection)

Budleigh Salterton

Like most towns and villages along Devon's coastline, Budleigh Salterton saw pillboxes built during the Second World War to defend itself against any seaborne German invasion.

Colcombe Castle

The village of Colyton once had a stone castle owned by the Courtenay family, who were the Earls of Devon with Tiverton Castle as their main seat. They built a mansion house on the site which was later fortified, modified and rebuilt numerous times. Ownership of the estate passed through a number of families and over this time its condition deteriorated. In 1644, during the English Civil War, it was the headquarters for the Royalist troops who used it as a base for their attack on Stedcombe, but it then fell into Parliamentarian hands and was almost completely destroyed. Today, very little remains, aside from one ancient building in the yard of Colcombe Abbey Farm.

A watercolour of Colcombe Castle by Revd John Swete dated 27 January 1795.

RAF Dunkeswell

Construction of the three 'heavy bomber standard' runways at RAF Dunkeswell began in early 1942 due to the need to tackle the increased threat of German U-boats to Allied shipping in what became known as the Battle of the Atlantic. With U-boat bases established along the French coast of the Bay of Biscay at Lorient, Brest and St Nazaire, German forces had direct access to the Atlantic, and with it, the supply lines that kept food and resources coming into Britain. Completed on 26 June 1943, it was handed over to American forces, with the American United States Army Air Forces Antisubmarine Command, 479th Antisubmarine Group, using it as a base to fly anti-submarine missions over the Bay of Biscay using specialized B-24 Liberator bombers from August until November 1943. The United States Navy then took command and continued these vital anti-submarine operations from the station, before moving to RAF Upottery in November 1944. These operations would take around twelve to fifteen hours, often flying countless hours without sighting or meeting the enemy. However, if their radar picked up a U-boat travelling on the surface of the water they could suddenly swoop in before dropping their lethal depth charges at between 100 and 250 feet. Orders to cease operations came on 28 May 1945.

Operations from Dunkeswell had found and attacked sixty-five U-boats, sinking seven and damaging another eleven. They took the surrender of another 5 vessels, but lost 23 Aircraft and 178 men in the process. From August 1945, the RAF used the airfield

for ferrying aircraft to the Middle East by 16 Ferry Unit, RAF Transport Command until April 1946 and in 1948, it was sold by the Ministry of Defence and is now used as a private airfield.

The airfield in action, 1944–45. (Courtesy of US Navy ©)

Another view of Dunkeswell in 1944–45. (Courtesy of US Navy)

The control tower today. (Courtesy of Mike Searle CC BY-SA 2.0)

Dymond's Farm POW Camp, Clyst Honiton and Country House Hotel POW Camp, Sidford

East Devon had a few prisoner of war camps during the Second World War, although like the vast majority of these installations across the country, there is no photographic evidence available and the majority of the sites have been completely removed.

Otterton

The Brandy Head Observation Post near Otterton was opened in July 1940 and was occupied by a team who observed the testing of new weapons on targets, initially out at sea but as the war progressed, in the surrounding fields too. There was a Gunnery Research Unit based at RAF Exeter, who flew down to test turret-mounted guns as well as wing and nose-mounted cannons. Just to the east of here was Home Down, an RAF emergency landing strip on the coast, which saw Allied and Axis crash-landings during the conflict. Sadly, in August 2019 planning permission was granted to convert the structure into holiday accommodation.

The RAF Observation Hut at Brandy Head. (Courtesy of Lewis Clarke CC BY-SA 2.0)

Sir Walter Raleigh

Another of England's greatest seafarers, soldiers, explorers, pirates and one of the most notable figures of the Elizabethan era, Sir Walter Raleigh was raised in Devon in the small village of Hayes Barton near East Budleigh. In his early life (between 1579 and 1583) he took part in the suppression of rebellion in Ireland and gained notoriety at the Siege of Smerwick, where he led the party that beheaded around 600 Spanish and Italian soldiers. He personally seized 40,000 acres of land, becoming one of Ireland's principal landowners, and his rise in favour with Queen Elizabeth I ultimately resulted in a knighthood in 1585. He was granted royal approval to explore Virginia, which made him one of the leaders of the English colonisation of North America. He was appointed Lord Lieutenant of Cornwall, Vice-Admiral of Devon and Cornwall and Captain of the Yeomen of the Guard.

However, in 1591, scandal struck. He secretly married one of the Queen's ladies-in-waiting, without the Queen's permission, and both he his wife were imprisoned in the Tower of London for two months in 1592. After he was released, he sailed to South America in 1594 after hearing about a 'City of Gold'. In 1596 he took part in the Capture of Cadiz and helped regain his royal favour by helping England defend itself against

Sir Walter Raleigh. (Loco Steve, CC BY-SA 2.0)

the 3rd Spanish Armada during 1597. After Queen Elizabeth I died in 1603, Raleigh was imprisoned for treason in the Tower of London for being involved in the main plot against King James I. Although convicted, the king spared his life and he was released in 1616 to lead a second expedition in search of El Dorado. However, during the expedition his men attacked a Spanish outpost, which was in violation of the 1604 peace treaty with Spain and his pardon, and when Raleigh returned to England he was arrested and executed in 1618.

Sidmouth

Pillboxes were built in and around Sidmouth during the Second World War and the town became an important location for the RAF, becoming known as RAF Sidmouth. Located on the A3052 on the way to Seaton, a 'chain-home' radar site was built in 1940 on the site now occupied by a caravan park. In 1942, a medical training depot moved to the town from Harrogate, and in the same year an officer cadet training unit and aircrew officers' school was established in the town.

This pillbox in Connaught Gardens not only formed the town's defences in 1940 but was later used by troops rehearsing for D-Day. (Courtesy of Raymond Cubberley CC BY-SA 2.0)

RAF Upottery

Made famous in 2001 by the publication of the book *Band of Brothers* by Stephen Ambrose and the subsequent television series, RAF Upottery is the airfield from which Easy Company of the 506th Parachute Infantry Regiment, 101st Airborne Division 'Screaming Eagles' flew to Normandy on D-Day. Also known as 'Smeatharpe', the airfield was built in preparation for operations to liberate Europe in the Second World War and was officially opened on 17 February 1944.

A standard RAF Class 'A' bomber base, its three runways were made from quarry waste, shingle from the beach at Seatown and a mixture of broken concrete and brick, reputedly from bombed buildings in Exeter. The 439th Troop Carrier Group, consisting of four squadrons and assigned to 50th Troop Carrier Wing, IX Troop Carrier Command, Ninth Air Force moved to RAF Upottery on 26 April 1944 and began training for the invasion of France that would occur later that year. They were equipped with over seventy Douglas C-47 Skytrains and on D-Day they dropped 1,357 paratroopers of the 1st and 2nd Battalion of the US 101st Airborne Division, as well as releasing gliders with reinforcements in the days that followed.

Over the summer, the carrier group moved elsewhere in Europe and was replaced by two Patrol Bombing Squadrons and asked to assist No. 19 Group, Royal Air Force Coastal Command with anti-submarine warfare patrols in the English Channel, Irish Sea and Bay of Biscay.

The airfield returned to RAF control on 31 July 1945 and ceased military operations in 1948. Today, all three runways remain and nearby there is a great museum about the airfield's history.

The 2052nd Aviation Engineer Fire Fighting Platoon at Upottery in 1944. (Courtesy of USAAF via Ted Heinbuch ©)

The control tower today. (Courtesy of Mike Searle CC BY-SA 2.0)

The main runway at Upottery. (Courtesy of Mike Searle CC BY-SA 2.0)

This is the 'Air Ministry Laboratory Bombing Teacher', a purpose-built building used to train aircraft bomb aimers. (Courtesy of Mike Searle CC BY-SA 2.0)

An original sentry box for the airfield is now used as a permanent memorial to the US men who served here. (Courtesy of Mike Searle CC BY-SA 2.0)

6. Exeter

The area we now call Exeter was the south-western end of the Fosse Way and because of this, the Romans established a large fort here which acted as the base for the 5,000-man Second Augustan Legion. A prosperous settlement soon developed around the fort and remained so until the Romans left Britain. Held by the Saxons and Danish Vikings, there would have been much bloodshed during these turbulent years.

In the years after the Norman conquest of 1066, Exeter rebelled against King William, prompting William to march west and lay siege to the town for eighteen days, eventually accepting the city's surrender. He arranged for the building of Rougemont Castle to strengthen his control over the locals and parts of it still remain today.

Exeter was bombed by the German Luftwaffe in the Second World War with a total of eighteen raids between 1940 and 1942 which flattened much of the city centre. A total of 265 people were killed and many historic buildings in the heart of the city were

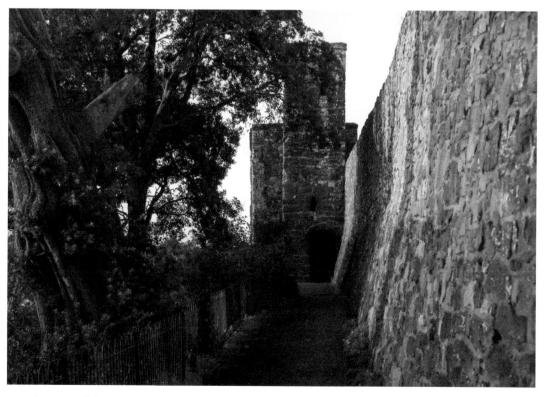

Remains of the city walls. (Courtesy of Alison Day CC BY-ND 2.0)

destroyed, whilst others, such as the cathedral, were damaged. April and May 1942 saw the worst of the attacks as they were part of the 'Baedeker Blitz' – a response to the RAF bombing of Lübeck and Rostock. However, 4 May 1942 was by far the darkest night of all, with 156 people losing their lives as forty German Junkers-88 bombers reduced 40 acres of the city to rubble. This would have been far worse had the RAF Exeter-based 307 Polish Squadron of night-fighters not performed so admirably, shooting down four enemy planes with only four of their own aircraft available! It should also be noted that there were two prisoner of war camps in the area – Bradninch POW Camp and Nissen Creek POW Camp at Pinhoe.

The Exeter blitz.

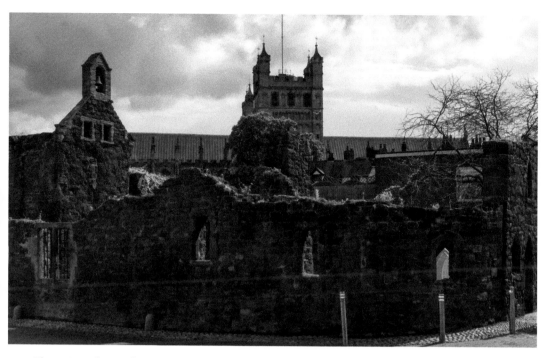

The ruins of St Catherine's Chapel and Almshouses, dating from 1457, were destroyed in the bombing during the Second World War. The ruins are now a memorial to those terrible nights. (Courtesy of Alison Day CC BY-ND 2.0)

RAF Exeter

The modern-day Exeter International Airport was the site of RAF Exeter during the Second World War, which was a very active fighter base on the front line of air defence in the south-west of England. Originally opened for domestic flights to the Channel Islands in 1937, the outbreak of war saw the airfield dramatically enlarged, with additional buildings and runways being built with great haste. The first unit to arrive and use the site was a department of RAE Farnborough, who flew into cables hung from barrage balloons to test different wire-cutting devices – the Pawlett Hams in Somerset was one location that housed such balloons. By June 1940, there was a gunnery Research Unit at Exeter from 'A' Flight Armament Testing Squadron who tested various types of guns and turrets on aircraft.

The site officially became RAF Exeter on 6 July 1940, with 87 and 213 Hurricane squadrons flying out to protect the Channel ports, as well as playing their part in the Battle of Britain. On 26 April 1941, No. 307 Polish Squadron came to Exeter, soon to be joined by 317 Squadron, and they helped defend the city during the blitz. In May 1942, Czechoslovakian Squadron 310 became stationed here, and by the end of the year as the war turned, thoughts moved from defence of the country to the eventual liberation of Europe. By April 1944, all RAF units were withdrawn and the airfield taken over by the US 9th Air Force as Station 463, as the 440th Troop Carrier Group arrived in preparation for D-Day. With them was the 3rd Battalion 506th Parachute Infantry Regiment Screaming Eagles, who dropped into Normandy on 6 June 1944.

This site building is one of the few wartime remains, due to the redevelopment of the site. (Courtesy of Richard E. Flagg)

By mid-1945 a succession of RAF squadrons had arrived and departed the airfield, before it was handed back to the Ministry of Civil Aviation in January 1946 with the RAF finally leaving in October 1946. Since then the airfield has been redeveloped significantly and now serves as a major transport hub for the South West.

Rougemont Castle

Two years after the Norman Conquest of England, it is believed that the Anglo-Saxons of Devon, Somerset and Dorset, together with the citizens of Exeter and Harold Godwinson's mother who lived in the city, refused to swear loyalty to William or pay the taxes he demanded. Although William's men were used to dealing with uprisings, I am sure the fact that the mother of the last crowned Anglo-Saxon king of England – a man William had just defeated and killed in battle – was directly involved, must have made his blood boil! In 1068 he marched to Exeter and lay siege to the city where he was met with fierce armed resistance. After eighteen days, the city surrendered, with the agreement that William would not harm its inhabitants, take their possessions, or increase the amount of tax they had to pay. With this, building began almost immediately of Rougemont Castle (sometimes known as Exeter Castle). The Domesday Book of 1086 reported that forty-eight houses had been destroyed in Exeter since the king came to England, with many historians interpreting this to mean that these houses were cleared for the building

of the castle. A large stone gatehouse, two corner turrets and ramparts were constructed and then enhanced in the following years with the construction of a protective barbican over the city side of the drawbridge.

In 1136, as part of his rebellion against King Stephen, Baldwin de Redvers successfully seized the castle and held out against counter-attacks from Stephen's men for three months, until the failure of his water supply, which had been provided by a well. It is thought that the barbican was captured and destroyed at this time, along with a tower.

In the late twelfth century, an outer bailey consisting of a wall with an outer ditch ran from the eastern city wall on the north side of Bailey Street to the western city wall near the current city museum. In 1497 the castle is said to have been badly damaged during the Second Cornish uprising when Perkin Warbeck and 6,000 Cornishmen entered the city, and by 1500 the original gateway was no longer used. Despite its illustrious past, the remains of the castle were in no fit state to be of any real use during the English Civil War (although the gatehouse was used as a prison), and despite there being at least four

The gatehouse of Rougemont Castle in Exeter. (Courtesy of Juan J. Martínez CC BY-SA 2.0)

King Richard III visited Rougemont Castle in 1483 and was impressed with its location in Exeter and the surrounding beauty. (Courtesy of Alison Day CC BY-ND 2.0)

artillery batteries on the site, the city fell to the Royalists in 1643 and then back to the Parliamentarians in 1646.

The County Court was built on the site in the eighteenth century and today, much of the old wall can still be found in situ around the city, along with the gatehouse and a tower.

Wyvern Barracks (located at Topsham Road)

Located on Topsham Road in Exeter, the site was first established around 1800 under the name of Topsham Barracks, where it was used for artillery. In 1873 the barracks became the depot for the two battalions of the 10th North Devonshire Regiment of Foot, evolving to become the Devonshire Regiment in 1881 and seeing action in the Second Boer War, the First World War and the Second World War. During the First World War, a reserve brigade of the Royal Field Artillery was based here and during the Second World War, as with a lot of military establishments across the South West, units of the United States Army were stationed here. In 1958, the Devonshire Regiment was amalgamated with the Dorset Regiment to form the Devonshire and Dorset Regiment and the barracks became the regional centre for infantry training under the name 'Wyvern Barracks' in 1960. Still in use, it is currently home to Battalion HQ, HQ Company and an Assault Pioneer Platoon of 6th Battalion, The Rifles and Exeter UOTC.

7. Teignbridge

One of the surviving pillboxes at Dawlish Warren. (Author's collection)

Dawlish Warren

This sand spit and National Nature Reserve spanning over 500 acres located at the mouth of the Exe Estuary would have provided a wonderful landing beach for an enemy invasion in the Second World War, so it is unsurprising that a number of defensive positions were built in 1940. At least eight pillboxes were constructed covering the only way off the spit, although sadly only two now remain.

Newton Abbot

The administrative centre of Teignbridge, Newton Abbot, like all centres of population, lost a number of men during the First and Second World Wars. In 1922 the town constructed a war memorial in their honour, with 232 names initially inscribed on the plaque. Since then nearly 150 names have been added from subsequent conflicts, including seventeen civilians lost during some of the sixty-five air raids the town suffered during the Second World War. One of Newton Abbot's public air-raid shelters in Courtenay Park has recently been restored by a local group, which helps to remember those dark days of the town's history.

The opening of Newton Abbot's war memorial. (Courtesy of Newton Abbot Town & GWR Museum)

The men of Newton Abbot's Home Guard. (Courtesy of Newton Abbot Town & GWR Museum)

Powderham Castle

Located on the west bank of the River Exe estuary, and a few miles from Exeter, Sir Philip Courtenay began constructing a fortified manor here in 1391. The Courtenay Earls of Devon had Tiverton Castle as their main stronghold and were a powerful family, but during the Wars of the Roses, the Bonville family of Shute, the Courtenay's enemies, took control of Powderham through marriage. As a result, in 1455 Thomas de Courtenay, the 5th Earl of Devon, brought a private army of 1,000 men, seized control of Exeter and laid siege to Powderham for two months. On 15 December 1455 the Earl of Devon and Lord Bonville met at the First Battle of Clyst Heath in Exeter, where Bonville was eventually defeated and Courtenay pillaged Shute.

By the time of the English Civil War, Powderham Castle had around 300 Royalist soldiers garrisoned there, and withstood a Parliamentarian attempt to take the castle in December 1645. However, a few months later in January 1646, it was taken, and the castle was badly damaged but remained in the hands of the Courtenay's. Since then, modifications have been made to turn this into a fine home, with only one of the original six towers, in the north-west, still standing.

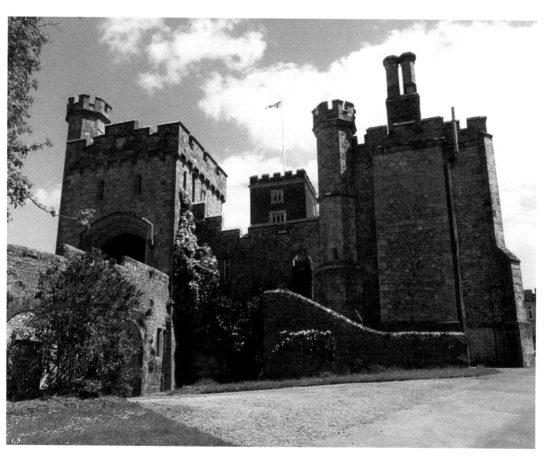

A view of the gatehouse to Powderham Castle, built in the Victorian era.

Viewed from the gatehouse, the tower on the left is the only original structure from 1390.

The east garden at Powderham.

8. South Hams

Bayard's Cove Fort

Bayard's Cove Fort was constructed sometime in the sixteenth century to protect the harbour of the coastal town of Dartmouth, which was an important trading and fishing port. There is no precise date, with some historians suggesting it was built at the start of King Henry VIII's reign in 1510 or later on in 1529. We do know that it was complete by 1537 and was constructed in response to the fears of a French or Spanish attack on the town. These fears grew over the next hundred years or so, leading the town to develop Dartmouth Castle into an artillery fort after 1486, and building Kingswear Castle in 1491.

By the time of the English Civil War in 1642, Dartmouth was a Parliamentarian town. This led Prince Maurice to lay siege to it before taking it for the Royalists relatively easily, as the town's defences all faced the sea and were vulnerable to a land attack. In January 1646, Sir Thomas Fairfax led a Parliamentary army to retake Dartmouth and

Bayard's Cove Fort as seen from across the River Dart. (Author's collection)

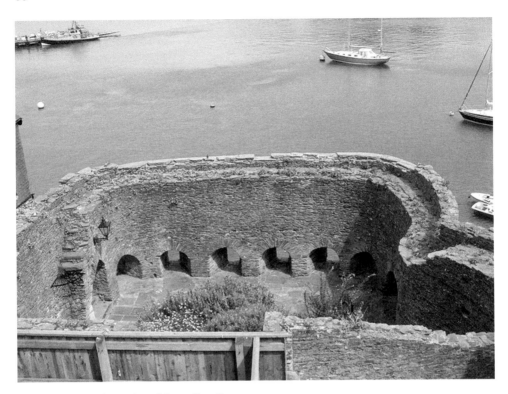

The gun ports and remains of the wall walk.

seized Bayard's Cove Fort and the five iron artillery guns stationed there. By 1662, the fortifications in Dartmouth were garrisoned by a royal force of twenty-three men, but it gradually fell into decline, being mainly used for storage. In the Second World War it was used a machine-gun post by the Home Guard, and the shell of this building is now free to visit, protected by English Heritage.

Berry Pomeroy Castle

The powerful Norman de la Pomeroy family was given the feudal barony of Berry Pomeroy just after the Norman Conquest of England in 1066, and although they developed a deer park here in 1207, the first reference to a castle does not appear until 1496, with most historians agreeing that the castle was probably built around this date in the late fifteenth century. The castle is located within the boundaries of the deer park and consisted of a dry moat, which is now mostly filled in, a splendid gatehouse that grabs your attention the first time you see it and ramparts enclosed by the curtain wall. The castle was bought by the Seymour family, who lived here in style until the Civil War when the castle was raided by Parliamentarians and the head of the family, Sir Edward Seymour, was imprisoned in London.

An inventory of the castle in 1688 indicates that the house contained around fifty rooms but from this point on, the castle fell into decline. The son of Sir Edward, also named Edward, was MP for Exeter and became Speaker of the House of Commons in 1673, and because of Berry Pomeroy's distance from London and the poor condition of the

castle, he preferred to live at Bradley House in Maiden Bradley, Wiltshire, stripping the castle of useful materials to fund the rebuilding of Bradley House, which he completed in 1710. The shell of Berry Pomeroy was left and is what we see today. It is interesting to note that the castle became a popular tourist destination from as early as the nineteenth century, with people keen to see this 'romantic ruin' overgrown with ivy.

The picturesque ruins of Berry Pomeroy Castle. (Author's collection)

Reputed to be one of the most haunted castles in Britain, two female ghosts are said to haunt the site: the White Lady and the Blue Lady. (Author's collection)

RAF Bolt Head and RAF Hope Cove

Located near Salcombe, RAF Bolt Head was a satellite airfield for nearby RAF Exeter during the Second World War. Built in 1941, the two runways saw a flurry of squadrons stationed here in the three years it was operational, with Spitfires making up the bulk of the aircraft used, particularly in 1944. There is a handwritten Memorial in Malborough Parish Church commemorating the lives of seventeen men who died whilst operating from Bolt Head, and the airfield ceased military activity at the end of the Second World War, in 1945.

Located at the perimeter of the airfield, and built at the same time in 1941, was RAF Hope Cove, which was a ground control interception (GCI) radar station. Part of the nationwide radar defence of the country, it helped to monitor air traffic in the English Channel and assist with directing fighter operations. Unlike the airfield, it continued its military life after the Second World War, becoming part of the United Kingdom's ROTOR

An aerial view of the site of RAF Bolt Head today. (Courtesy of Richard J. Flute)

A view of the bunker at RAF Hope Cove. (Author's collection)

network in the 1950s as the Cold War began. Although now decommissioned, there remains a semi-sunken R6 bunker, which is now a Grade II listed building.

Compton Castle and Sir Humphrey Gilbert

Although named 'a castle', Compton is essentially a fortified manor house that has never seen any aggression or fighting. Originally built by Sir Maurice de la Pole in the reign of King Henry II, it came into the hands of the de Compton family, which is where it takes its name. The original undefended manor house consisted of a hall with service rooms at each end, and in 1329, marriage between Joan de Compton and Geoffrey Gilbert brought the ownership to the Gilbert family, who enlarged the site in the 1450s. In response to French raids on Plymouth in the 1520s it was fortified by John Gilbert, and although it fell into ruins by the nineteenth century, it has been restored to this period and is run by the National Trust.

In 1539, Sir Humphrey Gilbert was born and lived in Compton Castle. Half-brother of Sir Walter Raleigh and cousin of Sir Richard Grenville, he too was an adventurer and explorer during the reign of Queen Elizabeth I and saw active service as a soldier in Ireland in 1567. He was elected as Member of Parliament for Plymouth in 1571 and famously took possession of Newfoundland for the English crown on 5 August 1583.

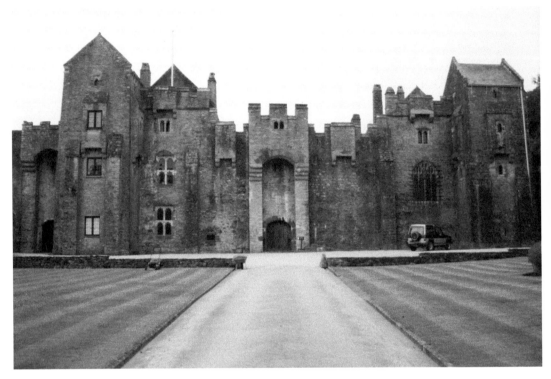

The fortified manor house that is Compton Castle. (Courtesy of Gerry Labrijn CC BY-SA 2.0)

Dartmouth Castle

Dartmouth Castle was built as an artillery fort to protect Dartmouth harbour from the threat of French and Spanish attack. It is believed the earliest parts of the castle date from the 1380s and incorporated the already existing local chapel of St Petroc within its walls. The castle was expanded in the fifteenth century and additional gun batteries were built in the 1540s. It is really interesting to note that one of the key parts to the defence of the harbour at the time was to stretch an iron chain across the harbour to a tower at Godmerock!

During the English Civil War, the Parliamentarian town of Dartmouth was besieged, and Prince Maurice took the castle (and its tiny garrison of five men) with ease in 1943 by positioning his artillery on the higher ground overlooking the castle – and its seaward-facing defences. It is thought that an earthwork fort called 'Gallants Bower' was built to protect this vulnerable position, but in January 1646, Sir Thomas Fairfax led a Parliamentary army to retake Dartmouth, forcing the surrender of the Royalist's castle commander.

By 1748 a new gun position called the Grand Battery was added to the castle along with twelve guns. The castle was again upgraded in 1859 with modern artillery, but by the twentieth century the castle was considered redundant and was open to visitors as a tourist attraction. However, it was brought back into use during the First and Second World Wars.

Dartmouth Castle. (Duncan Barnard, CC BY-SA 2.0)

Dartmouth Castle has a number of cannons still in situ. (Courtesy of Gerry Labrijn CC BY-SA 2.0)

Kingswear Castle

Kingswear Castle was built between 1491 and 1502, a few years later than Dartmouth Castle and on the opposite bank of the River Dart, providing increased protection for the river entrance and harbour. Similar in design to Dartmouth Castle, it had artillery based

A view of Dartmouth Castle and Kingswear Castle on the opposite bank. (Courtesy of Matthew Hartley CC BY-SA 2.0)

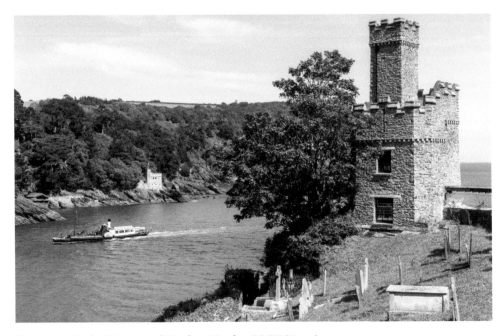

Kingswear Castle. (Courtesy of Matthew Hartley CC BY-SA 2.0)

there, but by the end of the sixteenth century, Kingswear was little used as the guns at Dartmouth were powerful enough to protect the whole of the river. It fell into ruin, but in the middle of the nineteenth century it was transformed into a summer residence, and it is now a holiday let.

Lentney and Renney Point Battery

With the significance of the docks at Plymouth, it is not surprising that a number of defensive forts were constructed in and around Plymouth Sound to ensure enemy ships would not be able to enter and take the strategically important city. Lentney Battery and Renney Point Battery were two such forts, being built between 1905 and 1906 to provide protection to the eastern side of Plymouth Sound. Designed to complement each other, Lentney contained short-range weaponry whilst Renney had longer-range guns capable of hitting armoured battleships. Both were used during the First and Second World Wars, with the guns at Renney able to reach 20 miles out to sea, as well as having anti-aircraft and mortar capabilities.

Entry to the magazines and barracks is still possible. (Author's collection)

Original machinery and signage are still in situ. (Author's collection)

Lentney Battery was decommissioned in 1956 whilst Renney Point Battery was disarmed in 1957 but used for training purposes right up until 1991. Today, both stand overlooking Plymouth Sound as they have done for the last hundred years.

Slapton Sands

The small village of Slapton, and its beach within the South Devon Area of Outstanding Natural Beauty, has a sad and regrettable mention in *Devon's Military Heritage*. During the Second World War, much of Devon saw an influx of US troops as preparations to liberate Europe intensified, and the area around Slapton was no different. In 1943, locals in the area were evacuated, and a training ground was established to be used by Force 'U', the American troops that eventually landed on Utah Beach in Normandy. The coastal bar beach provided the perfect location for large-scale rehearsals for the forthcoming D-Day invasion and in April 1944, one of the larger operations, 'Exercise Tiger', took place. Simulating crossing the Channel and landing in France, troops boarded ships on 26 April and the first practice assault landed on the morning of 27 April. To acclimatise the troops to the sights and sounds of bombardment, live ammunition was used on the approach and during the landing itself. However, several landing ships were held up and the start was delayed by an hour. Not everyone received this message. The Second wave of landing craft disembarked at their original time, resulting in a number of friendly fire casualties. Worse was to come. The following day, Convoy T-4, consisting of eight LSTs carrying

tanks, vehicles and combat engineers of the 1st Engineer Special Brigade, was attacked by nine German E-boats in Lyme Bay. Two LSTs sank and a total of 749 servicemen lost their lives over those two days. These exercises were under the strictest secrecy at the time and as a result, the full details of this disaster only became apparent after the war. A submerged Sherman tank belonging to the 70th Tank Battalion was later raised, with significant help by local residents, and now stands as a memorial to the incident.

Right: US troops on Slapton Sands. (Courtesy of US Signal Corps)

Below: Landing craft on Slapton Sands. (Courtesy of US National Archives)

The Sherman tank memorial at Slapton Sands. (Author's collection)

An LST on the beaches of Normandy. (Courtesy of US National Archives)

Totnes Castle

Occupying a prominent position on a hill above the town, Totnes Castle was first constructed of wood in the immediate aftermath of the Norman Conquest of 1066. It is believed that a few hundred years later, the wooden structures were replaced with the stone ones, but by 1326 the castle was ruined and no longer used. However, the castle was refortified with a new shell keep, and that is what we see today, making this one of the best-preserved motte-and-bailey castles in the country. The simple yet effective stone keep at the top is made from Devon limestone and has incredible views over the town, making those early years of control easy for the Crown. The curtain walls from this period remain intact too, and although the castle was occupied for a period during the English Civil War, it saw no action of note. It is now a Grade I listed building and maintained by English Heritage.

Totnes Castle is one of the best examples of a Norman motte-and-bailey castle in England. (Author's collection)

Inside Totnes Castle. (Author's collection)

Watch House Battery

Another one of the many batteries built to defend Plymouth Sound, Watch House Battery was a smaller fort constructed in the nineteenth century with five gun emplacements. In 1901 the battery was reconstructed and in the First World War the battery was manned by the Devonshire Royal Garrison Artillery. After being manned in the Second World War the battery was decommissioned in 1956.

9. Torbay

ROC Berry Head

Berry Head has always had a commanding position, with evidence of defensive works and forts being built before and after the Napoleonic Wars. In 1940 the Observer Corps built an aircraft reporting post here and in 1942 the post was equipped with rocket flares for directing fighters onto the track of enemy aircraft. At the end of the Second World War, Brixham ROC Post was stood down – but only until 1947, when the posts were reopened as the Cold War loomed. In the late 1950s the role of the Corps changed from aircraft plotting to the nuclear role, and an underground bunker was built and used as a nuclear monitoring station in the Cold War right up until 1991. The access shaft to the underground bunker is clearly still visible.

The entrance to the ROC post at Berry Head. (Author's collection)

Brixham

Brixham, and specifically its beach, played an important part in one of the country's most significant moments, when William of Orange launched the 'Glorious Revolution'. James II became King of England in February 1685, but his Catholicism meant that there was great unrest between the parliaments of England and Scotland, who were staunchly Church of England. However, this was seen as a short-term issue, as the fifty-two-year-old king had an eleven-year childless marriage, leaving his daughter, Mary, the heir presumptive. She was raised as an Anglican, and married her Protestant first cousin, William of Orange, in 1677. This all changed on 10 June 1688 with the birth of the king's son, James Francis Edward, and there was the very real prospect of a Catholic dynasty being created. William had surprisingly strong support within the English army to launch a revolution and claimed to be ensuring the rights of Parliament and James' daughter Mary as a Protestant heir. With a naval force that outnumbered the English by 2-1, his fleet of 463 ships and 40,000 men assembled in October 1688. On 5 November 1688, William landed in Torbay and over the next

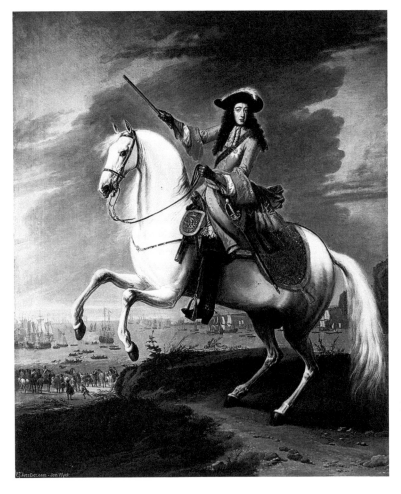

A portrait of William III by Jan Wyck, commemorating his landing at Brixham.

ten days his force disembarked onto English soil. He took Exeter, the English navy declared for William and he marched into London on 17 December, taking over the provisional government on 28 December. William and Mary were crowned together at Westminster Abbey on 11 April 1689 by the Bishop of London, becoming joint sovereigns, William III and Mary II.

Brixham is also the site of a battery that was originally constructed in 1586, defending the town from the threat posed by the Spanish. During the American Civil War of Independence towards the later part of the eighteenth century, additional gun emplacements were installed at what is now 'Battery Gardens' as Brixham was an important port for the navy. This expanded site of 14 acres saw 24-pounder guns arrive in May 1780, and the fort was used during the French wars, being manned by the 11th Devon Artillery Volunteers, Royal Garrison Artillery.

The battery was used for gunnery training during the 1870s and was used as a coastal lookout during the First World War. The Second World War saw Brixham battery receive additional weaponry to that of the existing 4.7-inch (120 mm) gun emplacements, with anti-aircraft defences and a 6-pounder Hotchkiss harbour defence gun brought in. The site

The gun floor for No. 2 gun. (Courtesy of Warwick Conway CC BY-SA 2.0)

The battery observation post still has a commanding view towards the breakwater. (Courtesy of Warwick Conway CC BY-SA 2.0)

was manned by different regiments from the Royal Artillery whilst being strongly supported by local men transferred from 'D' Company (10th Torbay) Battalion Devonshire Home Guard. A number of structures still remain, such as the observation post, gun floors and searchlights, and Brixham Battery Heritage Centre ensures that these important relics are preserved.

Torquay

Situated on the largest bay in Torbay, Torquay became an ideal town in which to convalesce injured servicemen in the Frist World War, with a Red Cross hospital opening in the town hall in August 1914, and soon followed with hospitals at Mount, the Manor House, Lyncourt Western Hospital and Royden. In September 1915 King George V and Queen Mary made a visit to the town, which also had seaplane base at Beacon Quay. Operated by the RNAS, it became No. 239 Squadron RAF in August 1918 and used Short Admiralty Type 184 planes as part of its anti-submarine patrols. With sheds along the front turned into hangars, these two-seat reconnaissance, bombing and torpedo-carrying folding-wing seaplanes remained operational from the town until May 1919.

US troops boarding landing craft for the liberation of Europe. (Courtesy of US National Archives)

US Army troops board an LVCP landing craft. (Courtesy of US National Archives)

During the initial stages of the Second World War, Torquay provided countless hotel buildings for the RAF to train aircrew and an RAF hospital at the Palace Hotel, which had over 200 beds. Evacuees began to flood into town, particularly from Bristol and Plymouth during the air attacks on those cities, but Torquay too suffered bombing raids, resulting in many deaths and the destruction of buildings. No 39 Air-Sea Rescue unit was based in Torquay Harbour and Sunderlands, flying boat patrol bombers, operated from a pontoon moored at Haldon Pier. In 1944, thousands of US Army personnel arrived in Torquay, as they did right across Devon, preparing for the launch of Operation Overlord. Many were initially billeted in private homes in St Marychurch, Upton, Chelston and Cockington. Already possessing a large harbour, it is unsurprising that embarkation ramps were constructed to help load up the large landing craft, and it is thought that more than 23,000 men of the American 4th Infantry Division departed from Torquay for Utah Beach in Normandy.

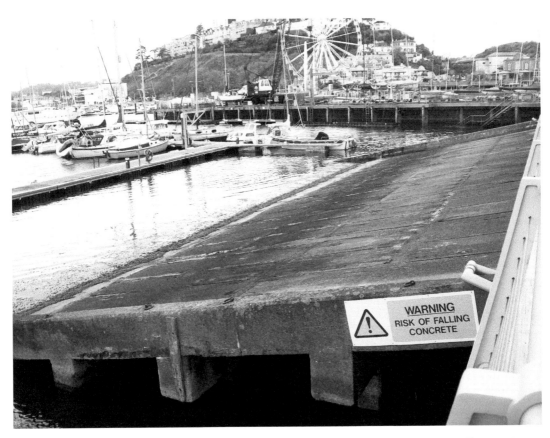

The D-Day embarkation ramps still remain in Torquay Harbour. (Courtesy of Len Williams CC BY-SA 2.0)

10. Plymouth

The city of Plymouth has a substantial military heritage that goes back centuries. Castles, forts, defences and, of course, the naval base at Devonport all have their own sections in the coming pages. The natural harbour of Plymouth Sound has meant that the city has a rich maritime history – from Drake setting off from Plymouth Hoe to defeat the Spanish Armada in 1588 to over 100 Pilgrims sailing to the New World aboard the *Mayflower* in 1620 – and as a result the city has always had huge military significance.

Since the Bronze Age there has been a settlement here worth fighting over, attacked in 1340 by the French and in 1403 the town was burned by Breton raiders. During the English Civil War, Plymouth sided with the Parliamentarians and because of its importance, it was besieged for nearly four years by the Royalists. When the civil war ended, Plymouth remained in Parliamentarian hands, but with King Charles II restoring the monarchy in 1660, a lot of those who fought were imprisoned on Drake's Island, leading to the construction of the Royal Citadel in 1665 with cannons facing both out to sea and into the town to remind the locals not to oppose the Crown.

Plymouth suffered heavily during the Blitz.

In the late nineteenth century, forts were constructed to defend the city from both the sea and the land, and by the time of the First World War, Devonport dockyard was an important base for escort vessels and repairs, with flying boats operating from Mount Batten. During the Second World War, Devonport was the headquarters of Western Approaches Command until 1941 and was an important embarkation point for US troops for D-Day in 1944. However, Plymouth's status as a major port meant that the city was heavily bombed by the Luftwaffe. In what is known as the Plymouth Blitz, fifty-nine air raids primarily targeted the dockyards, but much of the city centre and over 3,700 houses were completely destroyed, with more than 1,000 civilians losing their lives. There were prisoner of war camps at Chaddlewood, Hazeldene and Home Park. Today the dockyard still plays an important role in the life of the city, generating around 10 per cent of the city's income, whilst 42 Commando of the Royal Marines are still based here.

Above: An anti-aircraft position in Plymouth, with Charles Church in the background.

Opposite: Charles Church has been preserved as a memorial to civilian victims of the Blitz. (Courtesy of N. Chadwick CC BY-SA 2.0)

82

The Naval Memorial in Plymouth.

An aerial photograph of Plymouth naval base, the largest in Western Europe. (Licensed under the Open Government Licence v3.0)

HMS *Westminster* inside the Frigate Refit Complex. (Licensed under the Open Government Licence v3.0)

HMS *Ocean* returns to Plymouth Sound in 2011 escorted by Devonport-based tugs. (Licensed under the Open Government Licence v3.0)

Agaton Fort

Agaton Fort was built between 1863 and 1870 to the north-west of the city, with clear views over Tamerton Lake. Part of the Northern Lines of defence, it had a surrounding ditch and twenty guns – or at least that was the plan. By 1893, there were just eight guns in place and as the need for the fort diminished, it was disarmed by the turn of the twentieth century. It was used as a military depot during the First and Second World Wars, before being sold in 1958.

Austin Fort

Overlooking the Forder Valley, Austin Fort was built to protect the north-east of the city. Designed to accommodate sixty troops, it was surrounded by a dry ditch that linked up to the front ditches of Forder Battery and Bowden Fort, protected by a two-storey guardhouse. Like other forts built in the area, the need for the fort faded as it was being built and it was never fully armed as intended. Austin Fort was used by the Devon and Cornwall Auxiliary Unit during the Second World War and is now owned by Plymouth City Council.

Bowden Fort

Bowden Fort occupied the lower ground to the east of the more important Crownhill Fort and was built with the intention of providing additional cover for it. There was only

accommodation for sixteen men, due to the close proximity of other barracks nearby, and it was equipped with seven 7-inch rifled breech-loading guns and a defensive ditch. Used sparingly, it was a military depot during the First and Second World Wars and it is now the site of a garden centre.

RNAS Cattewater/RAF Mount Batton

Opposite Sutton harbour, the historic old port of Plymouth, is a rocky peninsula that has been occupied for its defensive qualities since the Bronze Age. Controlling access to the River Plym and Sutton Pool, as well as separating Cattewater from Plymouth Sound, in 1588 following the outbreak of war with Spain a small earthwork artillery position was built here, and it has been used ever since. During the English Civil War, Royalist forces besieged Parliamentarian Plymouth and occupied this site, making it impossible for the city to be resupplied from Sutton harbour. No sooner had the Civil War ended, the First Anglo-Dutch War began, and a new tower was built to replace the older Elizabethan gun battery as the British navy was anchoring its fleet in the Cattewater and needed additional protection. This three-storey circular tower had a ten-gun battery installed on the flat roof

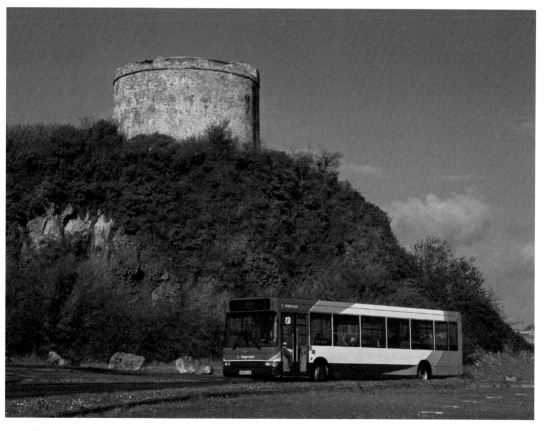

Mount Batten Tower. (Courtesy of Nick Rice CC BY-ND 2.0)

and was named Mount Batten, remaining in military use until 1716, when it became an observation post.

However, this location regained its military use in 1913, when it became Royal Naval Air Station (RNAS) Cattewater, a seaplane base that was rebranded as RAF Cattewater and used during the First World War. In 1928, it was renamed RAF Mount Batten, becoming the home of No. 204 Squadron, who operated Supermarine Southampton flying boats. During the Second World War anti-aircraft guns and anti-ship and submarine searchlights were installed as the squadron used Short S25 Sunderland long-range aircraft for patrols over the Atlantic to help counter the threat from German submarines. It was decommissioned in 1986.

Crownhill Fort

In 1859, a Royal Commission was set up to investigate Britain's military readiness to a potential French invasion. It was decided that key military locations, like Plymouth, should be protected by rings of forts, and as a result, over twenty installations were built in the area, with Crownhill Fort being the largest fortification in the Plymouth region and the best preserved. As the focal point of the Northern Lines of defence, it was,

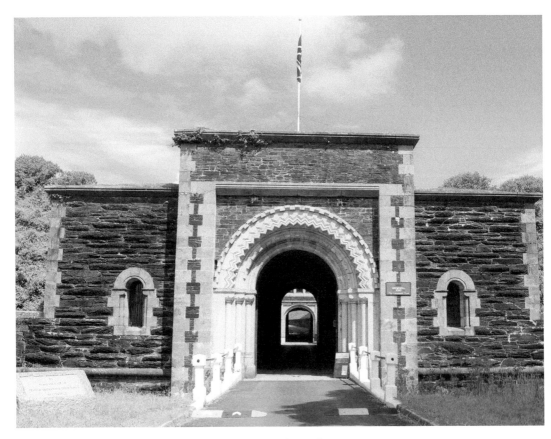

A view of Crownhill Fort's gatehouse. (Author's collection)

unusually for its time, positioned in an exposed position so its formidable fire power could dominate the area. With thirty-two guns, six of which were enclosed in casemates, mortars and ditch, Crownhill was fully armed with its complete complement of weapons right into the late nineteenth century.

During the First World War it was used as a transit depot for soldiers en route to the Mediterranean and then became home to the 2nd Battalion of the Royal Devonshire Regiment. The Second World War saw anti-aircraft guns installed here as the existing facilities made this an ideal location. After the war, Crownhill became the headquarters of the Commando Support Squadron, Royal Engineers and they provided logistical support during the 1982 Falkland's War. Decommissioned in 1985, it was purchased by the Landmark Trust and remains in excellent condition today.

Devonport

The dockyard at Devonport has been supporting the Royal Navy since 1691, when William III (formally William of Orange) required the building of a new Royal Dockyard to the west of Portsmouth. The first successful stepped stone dry dock

HMS *Drake* – part of Her Majesty's Naval Base, Devonport. (Licensed under the Open Government Licence v3.0)

in Europe was built (later rebuilt in the 1840s) and over the next two and a half centuries it expanded both southwards and northwards. As the largest naval base in Western Europe, the Devonport site covers more than 650 acres and has fifteen dry docks, 4 miles of waterfront, twenty-five tidal berths and five basins. Although shipbuilding ceased in the early 1970s, ship maintenance work has continued with the base employing 2,500 Service personnel and civilians, supports around 400 local firms and generates around 10 per cent of Plymouth's income. It was the base for the Trafalgar-class nuclear-powered hunter-killer submarines and has a long-term role as the dedicated home of the amphibious fleet, survey vessels and half of the frigate fleet. Until the early twenty-first century the naval barracks on the site was named HMS Drake but that name, and its command structure, has been extended to cover the entire base.

Drake's Island

The ongoing war with France in the mid-sixteenth century saw a garrison stationed at Drake's Island in 1551 with a stone and turf wall being constructed for its defence. By the 1590s, as war with Spain was on the horizon, the fortifications were strengthened, with over forty guns being installed along with an increased garrison of one hundred. In the aftermath of the English Civil War, notable Parliamentary prisoners were held here, and in the late eighteenth century, new magazines were built along with other small improvements.

In the mid-nineteenth century, large casemates were constructed on the island along with improved accommodation for those working there. During the Second World War, a twin 6-pounder gun was installed, and Drake's Island was garrisoned by around 500 soldiers who supported coastal defence and anti-air operations.

Drake's Island – located in a perfect position right in the middle of Plymouth harbour. (Courtesy of Robert Pittman CC BY-ND 2.0)

Fort Efford

Built on a hill overlooking a bend in the River Plym and forming part of the Northern Line defences of the city, Fort Efford had eleven 7-inch guns (which became sixteen in 1893) and accommodation for over 100 troops. It is now owned by Plymouth City Council.

Ernesettle Battery

Ernesettle Battery, the furthest west of the Northern Lines of defence, covered the all-important Tamar Valley. There were barracks for sixty men, six mortars positions and facilities for fifteen guns, although like most of the installations built around Plymouth at the time, Ernesettle Battery never became fully armed as intended. Disarmed before 1900, it remained in military ownership and was used as an anti-aircraft observation post during the Second World War. The site remains part of the Ernesettle Royal Navy armament depot.

The overgrown entrance to Ernesettle Battery. (Author's collection)

Sir John Hawkins

Born to a prominent family in Plymouth in 1532, Sir John Hawkins was an English naval commander and administrator, shipbuilder and privateer. First cutting his teeth as a trade merchant in 1562, Queen Elizabeth I invested in Hawkins by leasing the old 700-ton ship *Jesus of Lübeck* to him in 1564. Sailing with his second cousin, Francis Drake, and with three smaller ships, he returned a year later with the trip a total success.

In 1571 Hawkins entered Parliament as MP for Plymouth and was later appointed as Treasurer of the Royal Navy in 1578. He argued for, and won a pay increase for sailors, with the theory that a smaller number of well-motivated and better-paid men would be more effective than a larger group of uninterested men! He rebuilt older ships and helped design the faster ships that withstood the Spanish Armada in 1588 – a battle he served as a vice admiral. Known as one of the foremost seamen of sixteenth-century England and the chief architect of the Elizabethan navy, Hawkins was knighted for gallantry and died in 1595.

Knowles Battery

Although the ground in front of Knowles Battery was covered by the Woodlands and Agaton Forts, Knowles Battery was constructed in 1869 to help provide additional defence. It had a ditch, thirteen gun positions and a two-storey guardhouse, which had the main magazine located underneath it. By the early 1900s the fort had become obsolete, but it was used during the Second World War as a barrage balloon site. After the war a school was built on the site and the now Grade II listed Knowles Battery is now part of Knowle Primary School.

Knowles Battery with the school behind! (Author's collection)

Plymouth Castle

It's a little bit surprising that at the time of the Domesday Book, Plymouth was only a tiny fishing village of just eighteen people and certainly didn't warrant a castle. It did obviously grow in size and stature, and in 1340 and 1377 it was attacked by a flotilla of French pirates, prompting the construction of a castle and other earthworks. Building began in the early part of the fifteenth century, with curtain walls 4 metres high and each corner having a great round tower as well as a chain that could be raised to prevent access to Sutton Pool. A barbican protected the castle's gateway and in 1400 its guns drove off a fleet of French ships, and in August 1403 it provided a safe haven to the locals when a Breton army landed at Cattewater and attacked the town.

In the years that followed the castle was neglected, and although it was still standing in 1588 during the Spanish Armada, weaponry had moved on enough for Sir Francis Drake to use the castle stone to build a new artillery fort on the Hoe. During the English Civil War, which saw Parliamentarian Plymouth besieged by Royalist troops, the castle was occupied by the defenders. This was the last action Plymouth Castle saw. Mount Batten Tower and the Royal Citadel became the new defences of the city, and with a population boom and a demand for new housing, the old crumbling castle saw its stone being taken for new projects. Today only a small portion of the gatehouse has survived.

Plympton Castle

After the Norman Conquest of 1066, an earth and timber motte-and-bailey castle was built on the site of a Saxon fortification. Surrounded by a ditch and with large ramparts, it helped in keeping the local population in check. However, in 1136 the then owner of Plympton Castle, Baldwin de Redvers, Earl of Devon, rebelled against the king and with the threat of royal reprisals, Baldwin fled the country, leaving his castle to be burnt to the ground.

The remains of Plympton Castle. (Courtesy of Bradley Darlington CC BY 2.0)

By the thirteenth century, the castle had been rebuilt in stone and in February 1224, the then owner, Fawkes de Breaute, was ordered to surrender Plympton and Bedford castles. When he refused, Robert Courtenay was sent to capture Plympton Castle. It is believed that the garrison held out for fifteen days before surrendering, after which Fawkes fled abroad and the Courtenay family took over ownership. The castle fell into a state of semi-disrepair but was upgraded at the outbreak of the English Civil War and used by Royalist troops as they besieged Parliamentarian Plymouth. Since then the castle was abandoned and nothing remains except the rather impressive motte.

Royal Citadel

The outbreak of the Second Anglo-Dutch War in 1665 resulted in the commissioning of a major new fortification, the Royal Citadel, to protect Plymouth. Built partly on the site of 'Drake's Fort' – an earlier artillery position built by Sir Francis Drake – it retained these fortifications within its design, whilst also having a dry ditch and large stone curtain wall surrounding the vast new position. The land was seized by the Crown, and soldiers from the Duke of Cornwall's Regiment were used to build the 12-metre-high walls in just two years. Being the principle defensive structure of the city, the Royal Citadel was regularly strengthened in the eighteenth and nineteenth centuries and has been continually used as a barracks. Today, the Royal Citadel is home to 29 Commando Royal Artillery unit, but the Ministry of Defence have announced their intention to withdraw from the installation by 2024.

View of the Royal Citadel and Plymouth Hoe to the left. (Courtesy of Steve Herring CC BY-ND 2.0)

"Guard turn out," R.G.A.

The Royal Guard Artillery inside the entrance to the Royal Citadel in 1905.

Woodlands Fort

Woodlands Fort occupies a ridge of high ground over the Budcreek Valley. Construction lasted seven years from 1863 to 1870, and was surrounded, like most forts at this time, by a ditch. A two-storey barrack block provided room for around 100 soldiers and it was designed to hold eighteen large guns. However, by 1885 the fort had received only eight 7-inch rifled breech-loading guns and was disarmed by 1900. It was used as a barracks in the First World War and used again in the Second World War – mainly for storage.

Acknowledgements

Researching the history of a place you have lived near for the vast majority of your life is an exhilarating and time-consuming process that has allowed me to discover new sights, sounds and stories. In this day and age, it is possible to do a lot of research online, but nothing compares to actually heading out and exploring things for yourself. Only then, when you see the history in its original environment, does it start to make sense. Investigating the different aspects of this book has led me to find out some incredible things and meet a number of wonderful people, all of whom have been willing to share their knowledge and expertise, and this is so important in passing on the history of our communities to the next generation.

However, this book has not been without its challenges. Condensing the illustrious history of Plymouth for example, a city steeped in this country's military heritage, is difficult, and inevitably I have not been able to write about every single aspect of some locations. Nor has it been possible to write about all the individual stories or events that have unfolded over the centuries. It has also been very difficult finding out about some of the older locations, such as Iron Age and Roman forts, as often there are no remnants of the structures (barring earthworks) remaining, or they have been built on top of by more recent structures due to the prominent location. Indeed, the Second World War features heavily as it is the most recent conflict and many of these structures used pre-existing features as its base.

I need to express my gratitude to the organisations, people and photographers who have kindly shared their knowledge and allowed me to use their photographic work in my book: Craig Smith, Richard E. Flagg, Richard J. Flute, Stephen Fryer, Richard Sumner and the Newton Abbot Town and GWR Museum.

I would also like to thank Nick Grant, Nikki Embery, Jenny Stephens, Becky Cousins and all at Amberley Publishing for their help in making this project become a reality, as well as my wife Laura and young sons James and Ryan, who accompanied me on many wonderful day trips across the length and breadth of Devon, a county with beautiful scenery and a rich military heritage.

About the Author

Andrew Powell-Thomas writes military history, local heritage and children's fiction books. He regularly speaks at events, libraries, schools and literary festivals across the South West and lives in Somerset with his wife and two young sons. With more books and events planned, it is possible to keep up with everything he is up to by following him on social media or by visiting his website at www.andrewpowell-thomas.co.uk.

Andrew's other titles available with Amberley Publishing:

The West Country's Last Line of Defence: Taunton Stop Line
Somerset's Military Heritage
50 Gems of Somerset
Historic England: Somerset
50 Gems of Wiltshire
Cornwall's Military Heritage
Wiltshire's Military Heritage

Also available from Amberley Publishing

SOMERSET'S
MILITARY HERITAGE
ANDREW POWELL-THOMAS